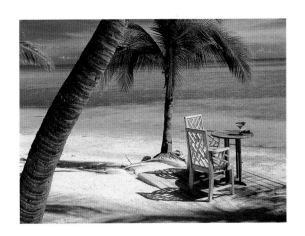

FLORIDA

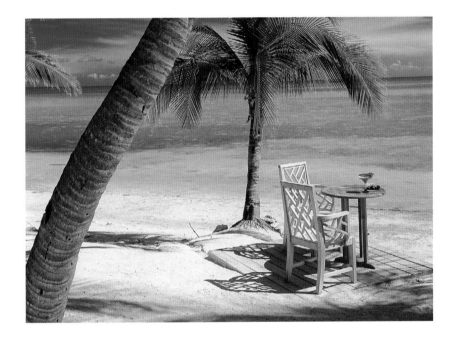

whitecap

Edited by Elaine Jones
Text and photo editing by Tanya Lloyd Kyi
Proofread by Lisa Collins
Cover and interior design by Steve Penner
Typeset by Maxine Lea
Printed and bound in China by WKT Company Limited.

National Library of Canada Cataloguing in Publication Data

Lloyd, Tanya, 1973–
 Florida
 (America series)
(hardcover)—
 ISBN 1-55285-253-9
 ISBN 978-1-55285-253-8
(paperback)—
 ISBN 1-55285-791-3
 ISBN 978-1-55285-791-5
1. Florida—Pictorial works. I. Title. II. Series: Lloyd, Tanya, 1973- America series.
F312L56 2001 975.9'063'0222 C2001-910981-4

The publisher acknowledges the support of the Canada Council and the Cultural Services
Branch of the Government of British Columbia in making this publication
possible. We acknowledge the financial support of the Government of Canada through the
Book Publishing Industry Development Program for our publishing activities.

*For more information on the Canada Series and other titles by Whitecap Books, please visit
our website at www.whitecap.ca.*

By the age of 50, Juan Ponce de León had accompanied Christopher Columbus on his second voyage to America and had conquered Puerto Rico for Spain. That would have been enough adventure for most people. But then Ponce de León heard of the legendary island of Bimini, nestled in the seas somewhere north of Cuba, home to a fountain of youth. In 1512, he and his Spanish supporters reached the shores of Florida and, believing it was Bimini, he sailed the inlets and bays of the coast in search of a route around the island.

Ponce de León never discovered his fountain of youth. Instead an arrow found its mark during an encounter with Florida's native people, who were far from eager to be conquered. Ponce de León died a few months later. But he had placed the crystal waters and white sand beaches of the coast on the maps of the European world, and the region was soon home to Spanish, French and English settlements. The early 1800s brought annexation to the growing United States of America.

One characteristic of Ponce de León has survived the intervening wars and centuries—his spirit of adventure. Flocking to Florida in record numbers, visitors find the expected sunshine and sand. But they also find the opportunity to explore. In Everglades National Park, sightseers tour the swamps in search of herons, bobcats, alligators, and the elusive panther. At St. Joseph Peninsula State Park, lights are banned on summer nights, allowing the occasional half-seen glimpse of a sea turtle on the sand. In the Florida Keys, divers and boaters encounter tropical fish, dolphins, and manatees in the world's third-largest living coral reef. Each region brings its quests and discoveries.

It's no wonder that some visitors to Florida cannot leave. The state now has the fourth-highest population in America, with almost 13 million residents. Most—85 percent—live in urban areas. Some, in the sun and splendor of Florida's coastline, in the fishing and diving, kayaking and parasailing, discover that Florida is, after all, the answer to Ponce de León's quest for eternal youth.

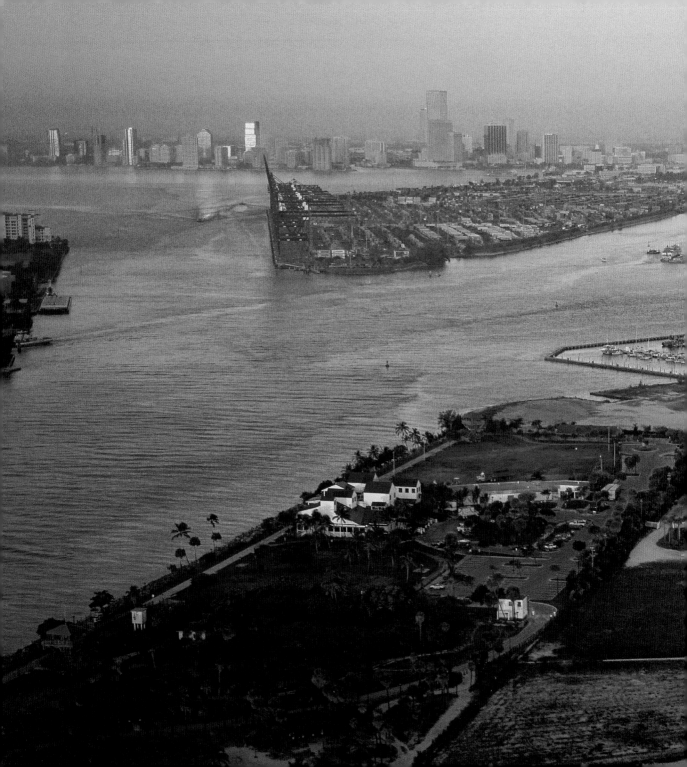

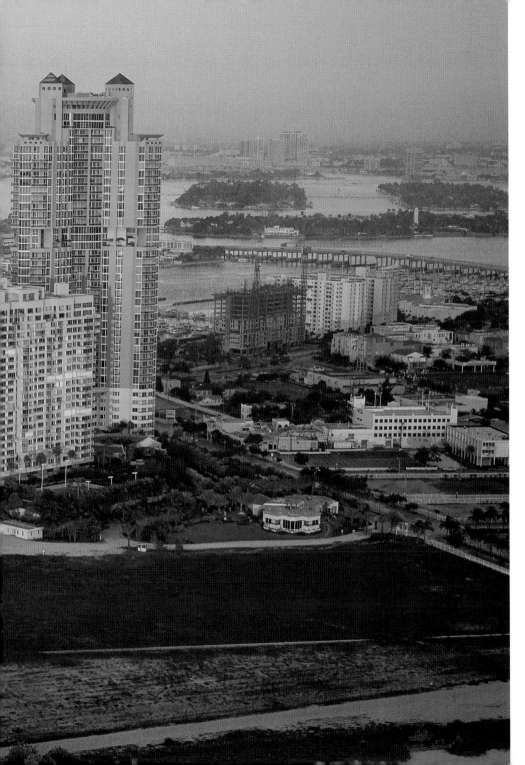

In the early 1900s, Miami Beach was home to coconut plantations and avocado fields. A hurricane in 1926 devastated a blossoming tourism industry, but by the 1950s and 1960s, Miami was once again a glamorous resort destination.

7

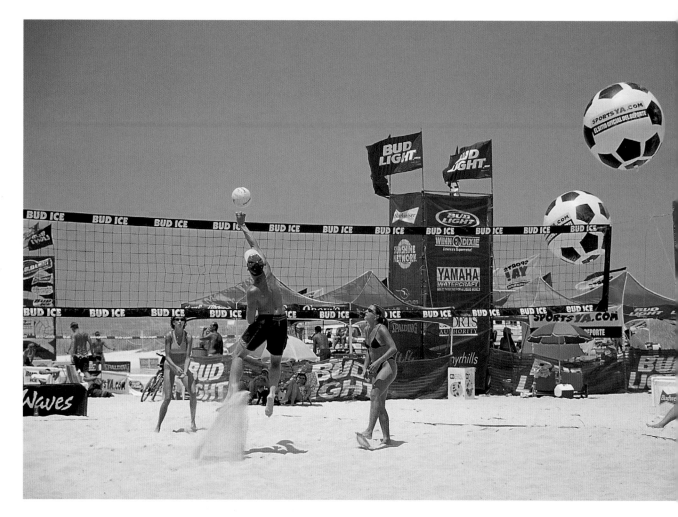

Beachside Lummus Park is a paradise of sunshine and watersports.
Ocean Drive borders the park, and runners, cyclists, and in-line
skaters share the sidewalks.

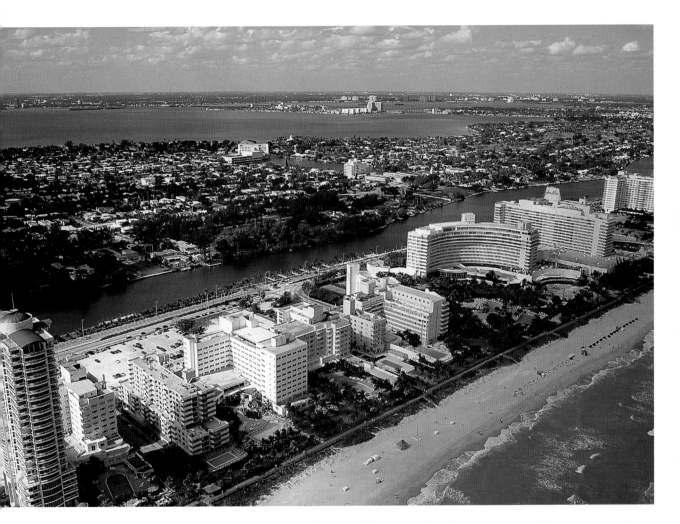

Home to more than 2 million people, Greater Miami offers year-round sunshine, unlimited recreation, and nonstop nightlife. It's no surprise that the city attracts 10 million visitors each year.

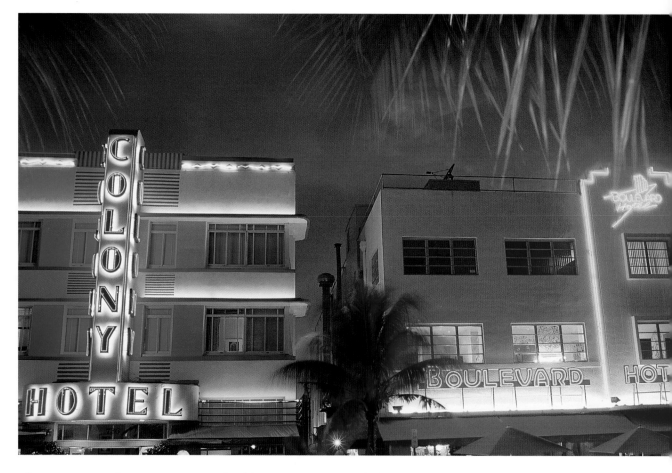

There are more than 800 Art Deco buildings in Miami. Built between the 1920s and 1940s, they were designed both to resist the force of hurricanes and to allow ventilation in the region's heat.

Built in 1916 for industry magnate James Deering, Vizcaya Museums and Gardens centers around a lavish Renaissance-style mansion. The 34-room complex, surrounded by lush grounds, is a national historic landmark.

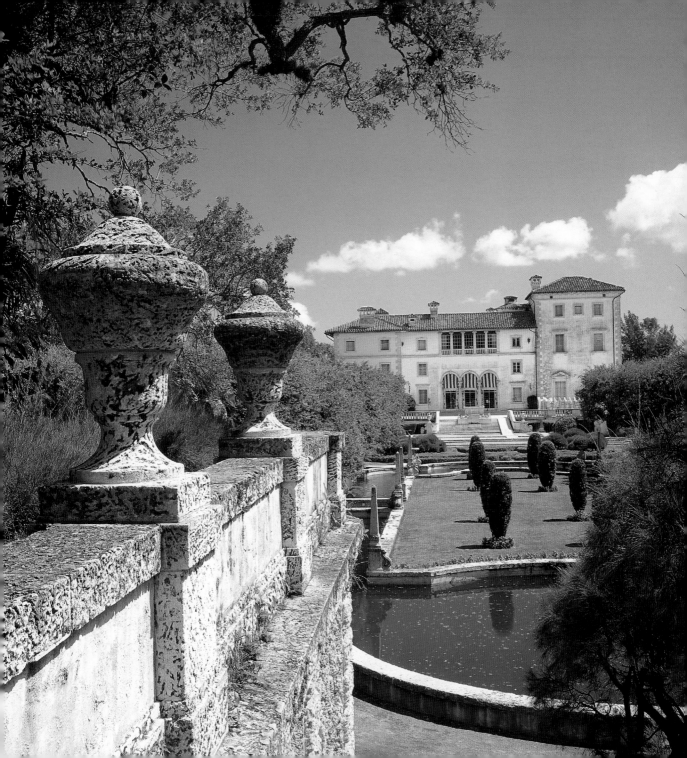

Miami Beach's inception as a vacation destination owes much to one woman—widow Julia Tuttle. After moving to Florida from Cleveland, Tuttle bought 640 acres of land and built a luxury hotel, and convinced oil and railway baron Henry Flagler to extend his rail line to the area.

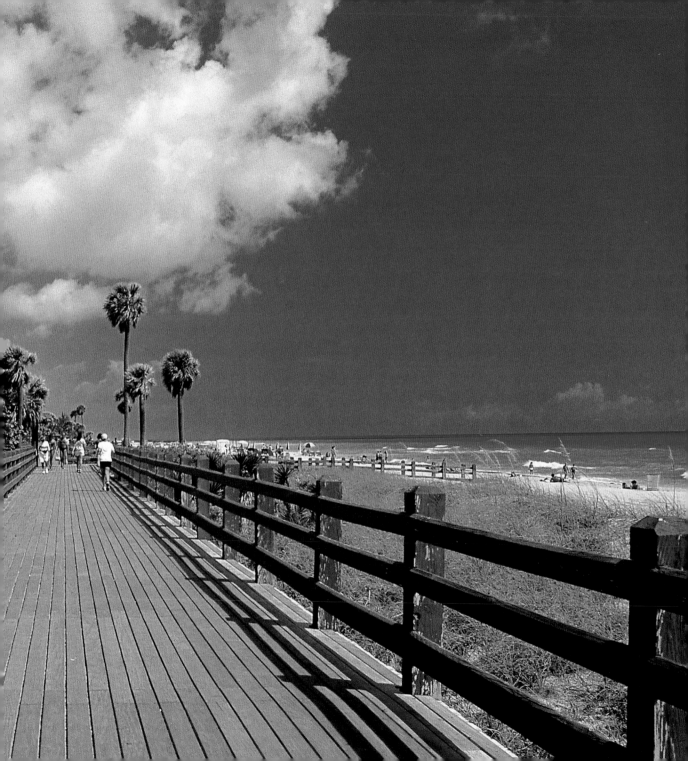

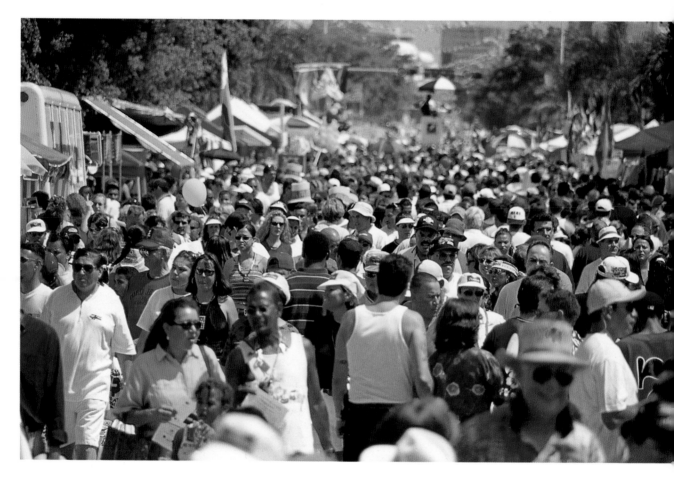

During the Calle Ocho Festival, Miami closes Southwest Eighth Street
to traffic and opens Little Havana to thousands of revelers. Billed as
the world's largest street party and the largest Hispanic festival in the
nation, the March event features Latin music, dancing, and food.

Everglades National Park has earned the designation of UNESCO
International Biosphere Reserve by helping to protect 13 endangere
species as part of the region's unique ecosystem.

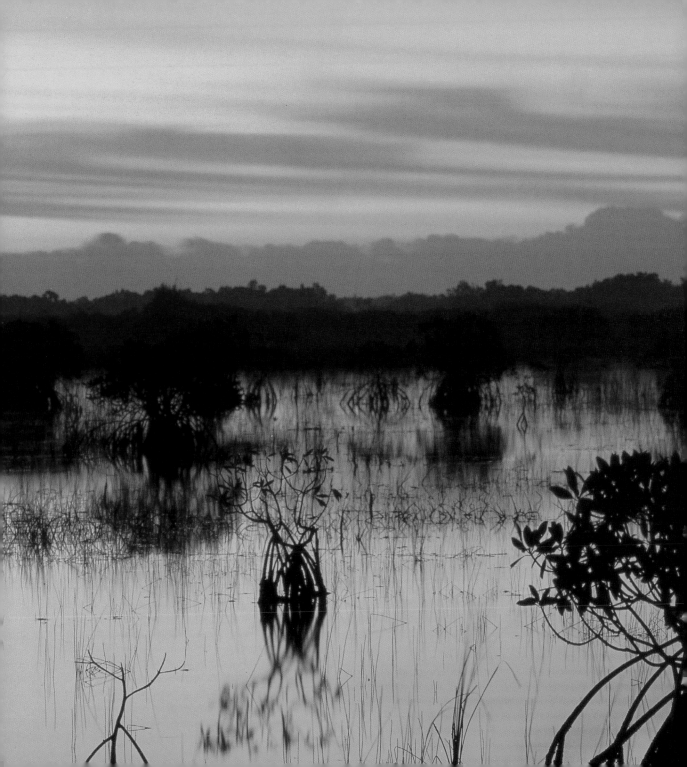

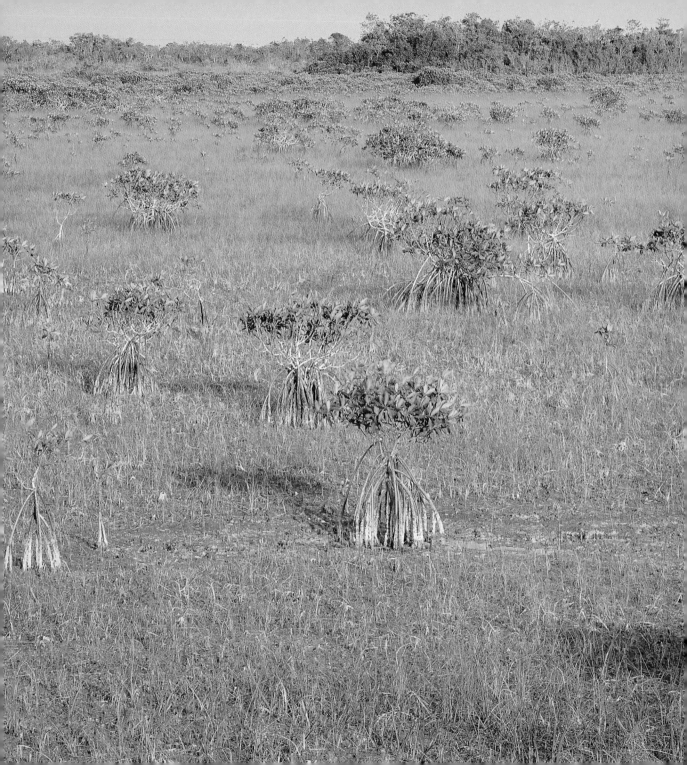

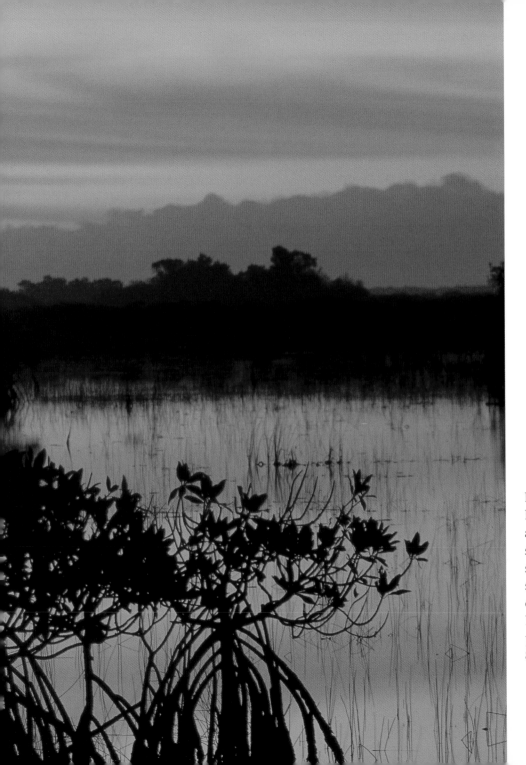

Everglades National Park has been called a river of grass. Wet season waters flow slowly over the land, spreading until most of the area is flooded. No point within the park rises more than 8 feet above sea level.

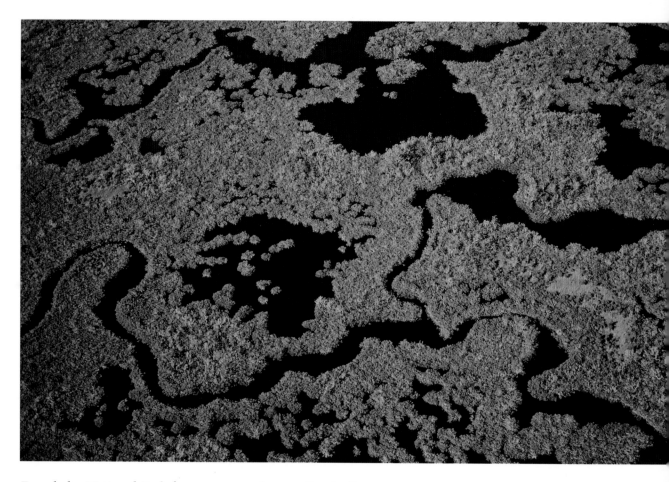

Everglades National Park faces constant threats. Canals divert water for commercial and agricultural use, leaving the park without the necessary nourishment. Pollutants, such as mercury, have leached into the floodplains, endangering wildlife.

American alligators usually move slowly on land in a lumbering walk. But by lifting their tails and walking on their toes, they can sprint up to 30 miles an hour. People are advised to remain more than 15 feet away from the animals at all times.

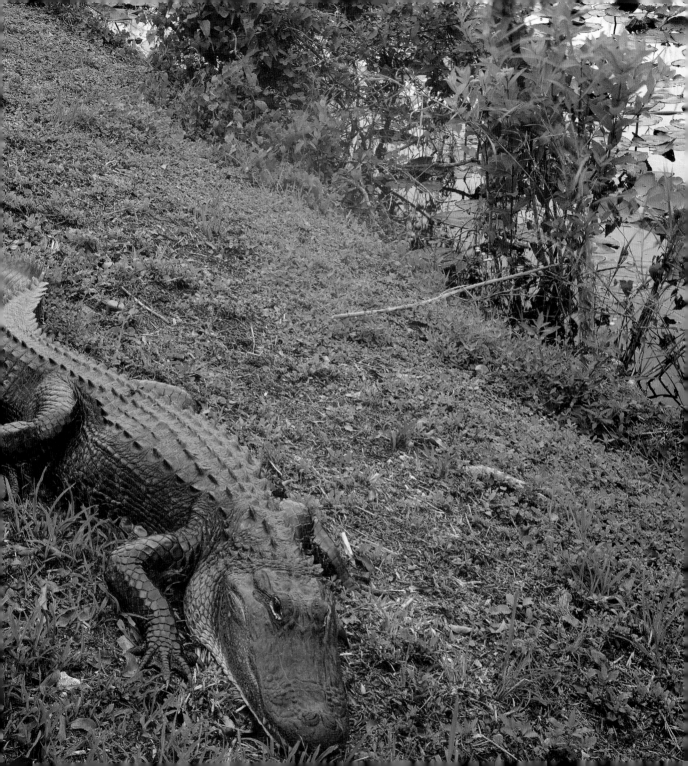

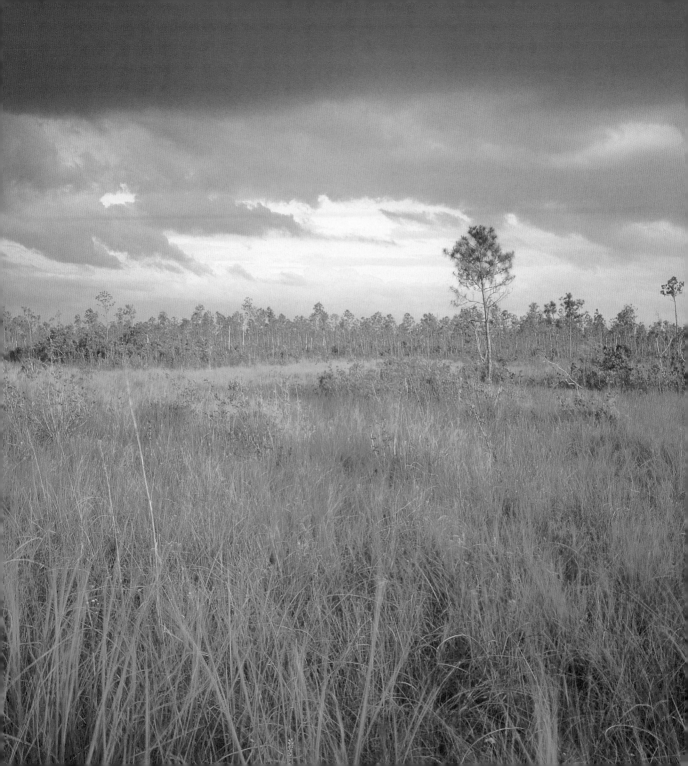

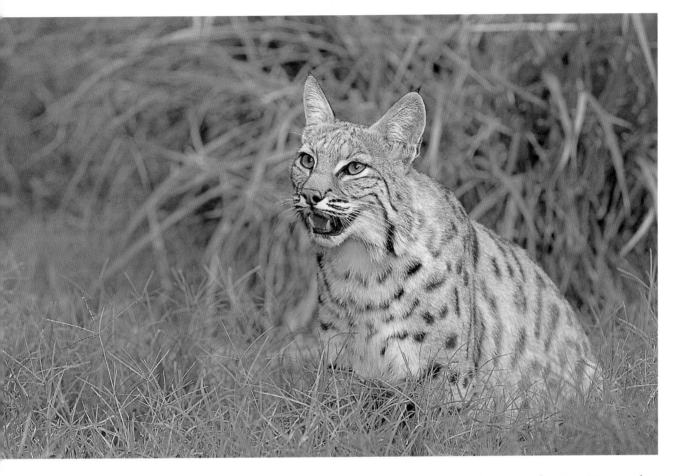

Common throughout the Everglades, bobcats weigh 15 to 25 pounds —two to three times the size of the average housecat. Primarily nocturnal, bobcats are occasionally spotted in the morning, stalking a small mammal or bird.

spring storm builds over the prairie. The plants that survive ere, squeezed between the tides of Florida Bay and higher round, are very hardy. Salt-tolerant, they must survive both equent floods and periods of drought.

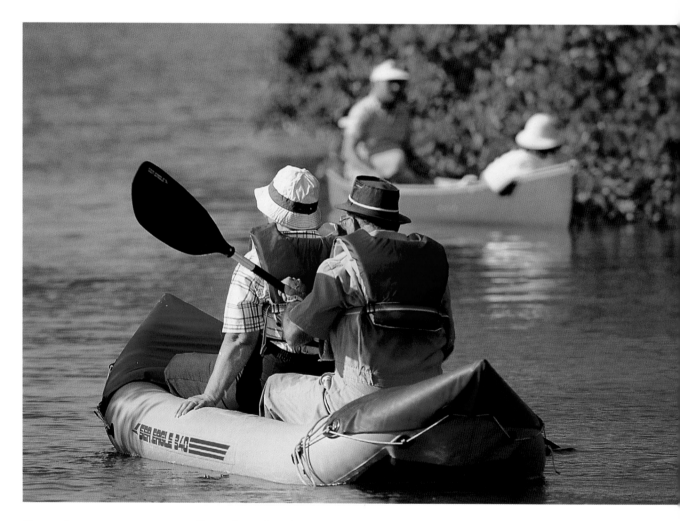

Forty-three mosquito species flourish within the Everglades. The
damp soil of the mangrove swamps and prairies provides a perfect
place for the insects to lay their eggs—up to 10,000 per square foot.

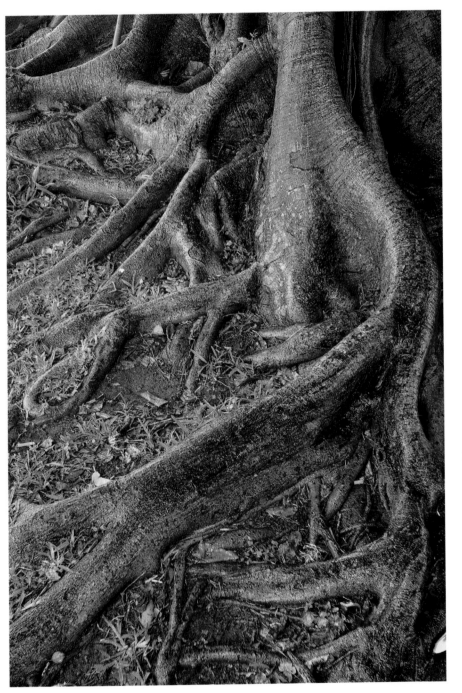

A strangler fig begins as a sticky seed, dropped onto a tree trunk by a bird or bat. Sending long, twining roots down, the fig eventually outgrows the host tree, strangling the trunk and shading the foliage.

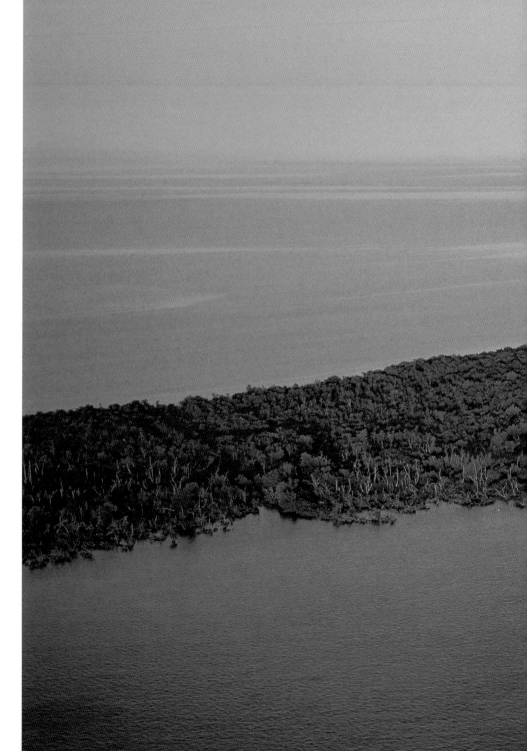

Biscayne National Park, the largest marine park in the nation, encompasses one of Florida's most extensive mangrove forests, more than 40 keys, and rich underwater reefs. Snorklers, divers, and boaters flock to the preserve, established in 1980.

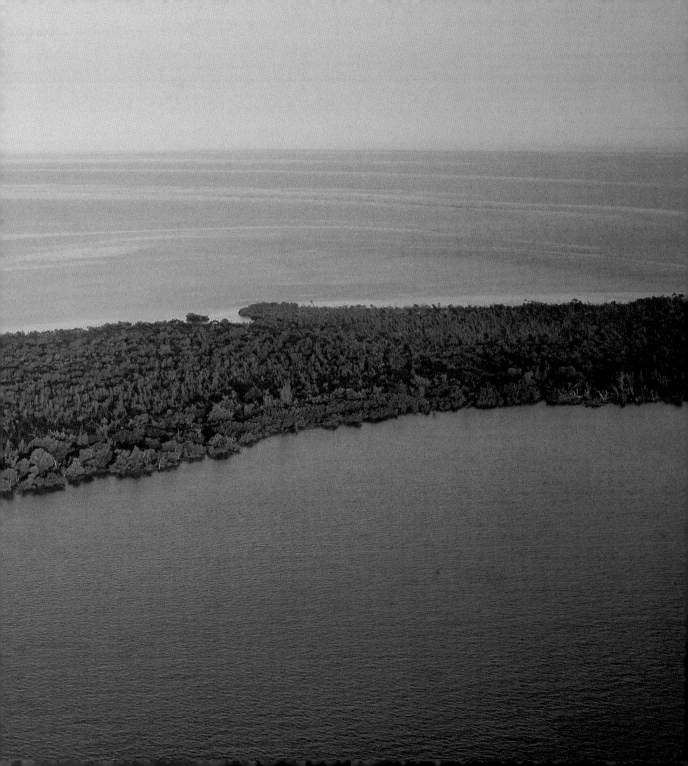

Situated on the edge
of Big Cypress Swamp,
where the waters drain
towards the estuaries of
the Ten Thousand Islands,
Fakahatchee Strand State
Preserve protects royal
palms and rare orchids,
cypress domes and
mangroves.

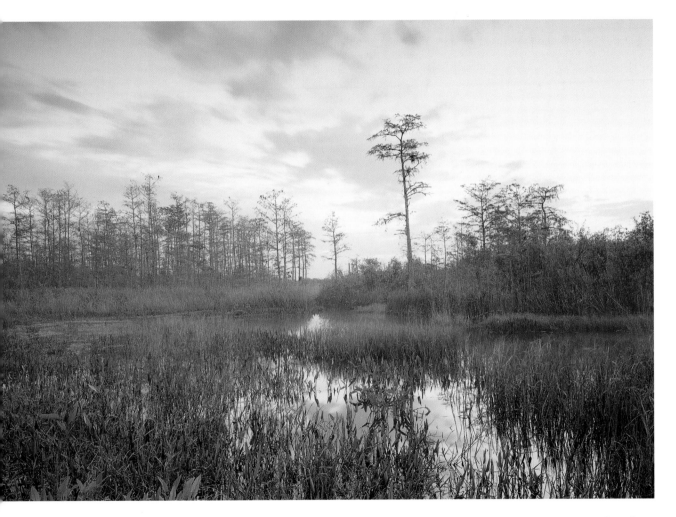

As human development encroached upon Everglades National Park, Big Cypress National Preserve was established in 1974 to buffer the park and protect another 729,000 acres of delicate wetlands. The park is home to some of the world's last Florida panthers—it is estimated that 30 to 50 still survive.

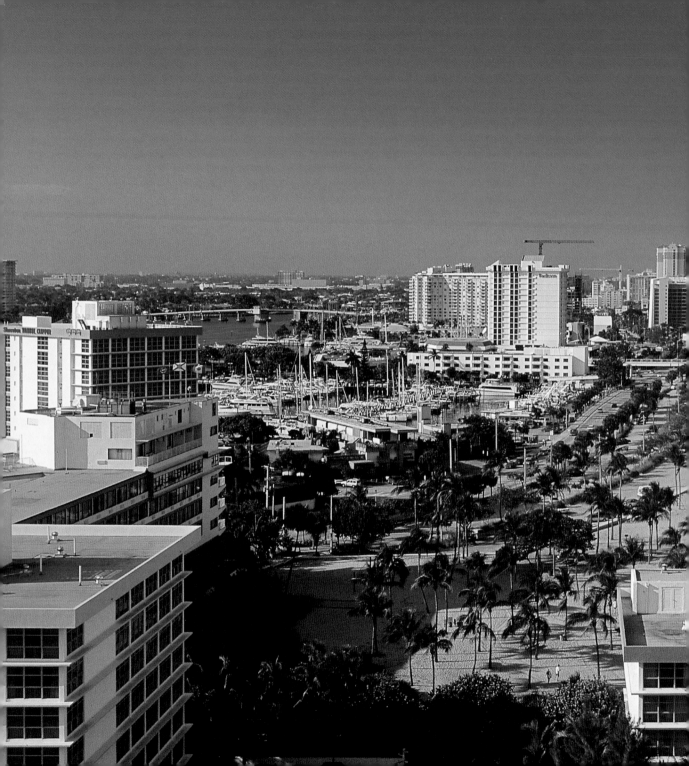

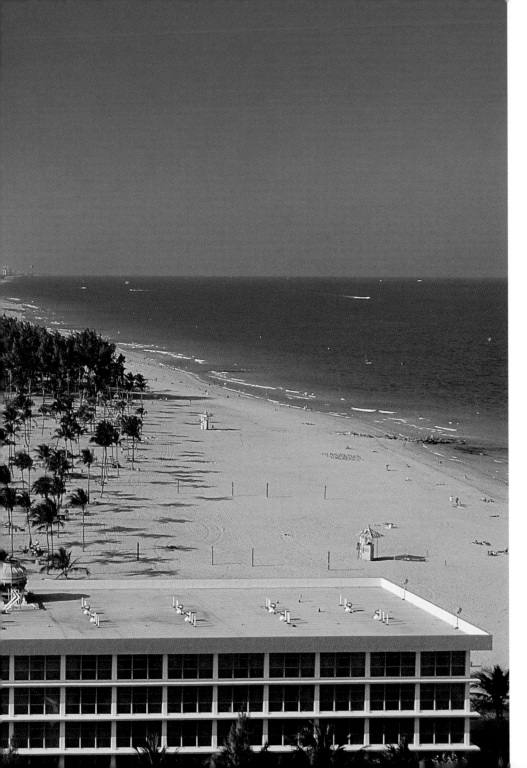

More than 600 hotels and resorts cater to Fort Lauderdale visitors. For most guests, the city's attractions lie along 23 miles of beaches. Fort Lauderdale is also where 80 percent of the world's yachts are sold.

At Flamingo Gardens in Fort Lauderdale, sightseers get an up-close look at Florida's flora and fauna. There are 60 acres of rare plants, an enclosure featuring the state's largest collection of wading birds, and specially designed habitats for flamingos, river otters, and alligators.

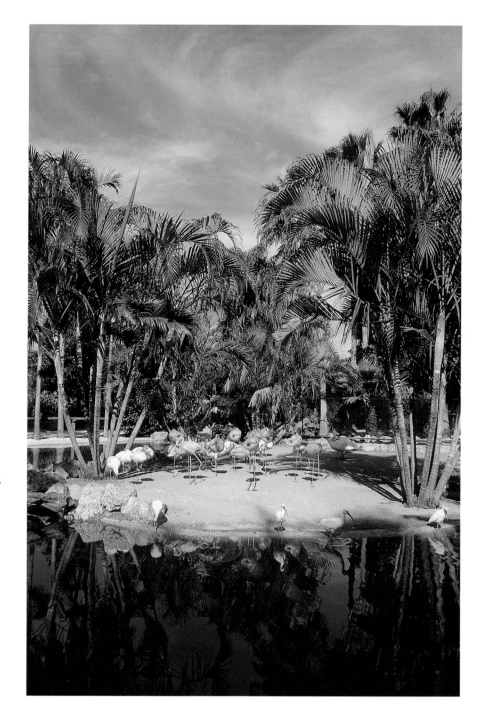

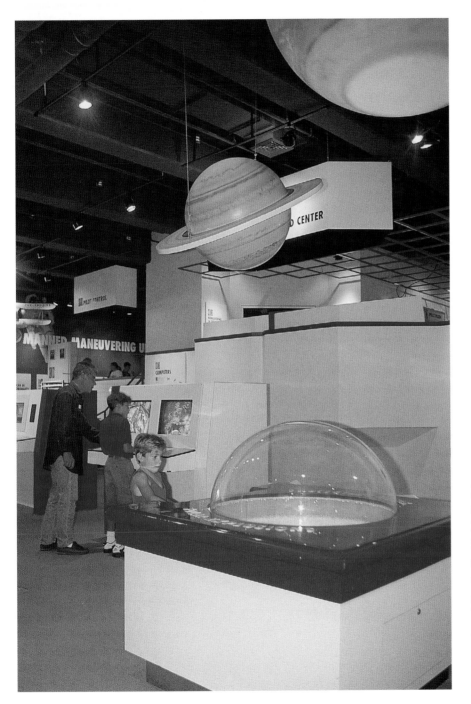

More than 200 interactive exhibits at Fort Lauderdale's Museum of Discovery and Science allow both children and adults a hands-on exploration of science and technology, from living coral reef to robots and satellites.

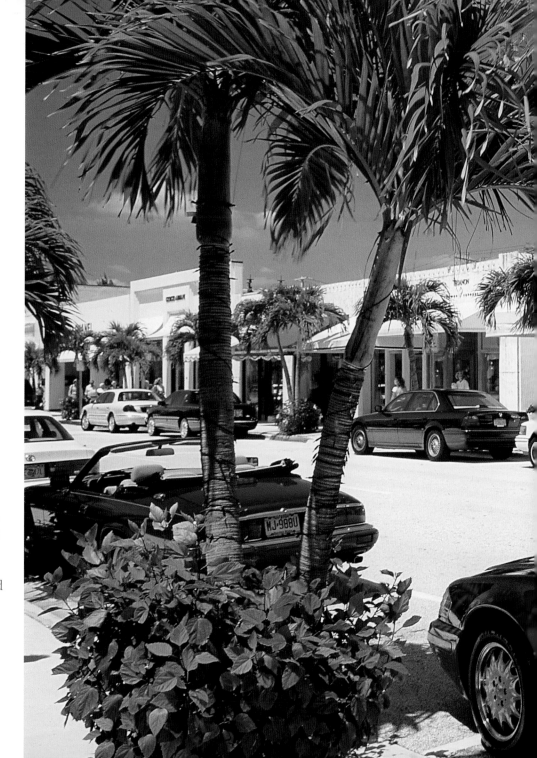

When Henry Morrison Flagler opened the Royal Poinciana Hotel in Palm Beach in 1894, he created an instant hit with Hollywood starlets and high society, who gathered here for the Palm Beach "season" between December and February.

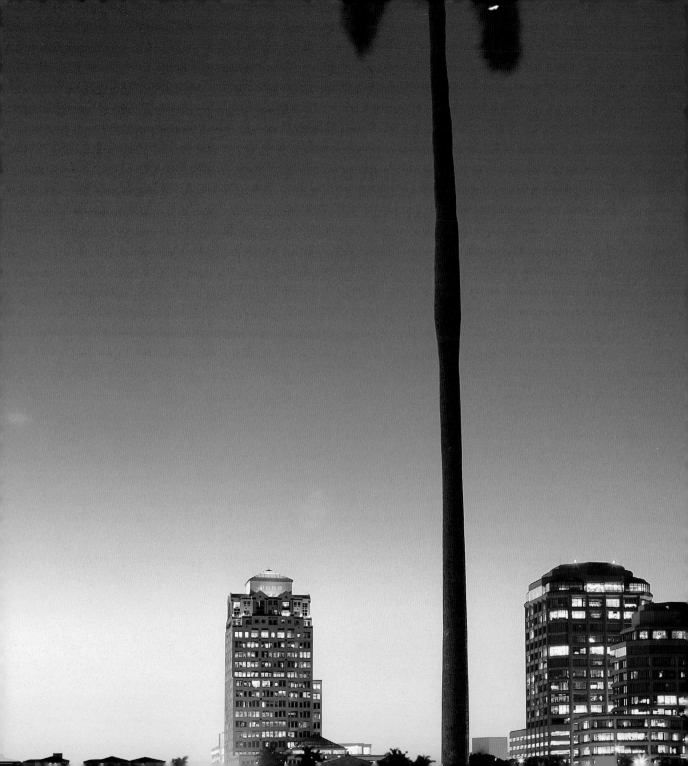

The skyline of West Palm Beach glows over Lake Worth at dusk. Home to the Port of Palm Beach and the Kravis Center for the Performing Arts, the International Airport and the Palm Beach Philharmonic, the city is a vibrant mix of industry and culture.

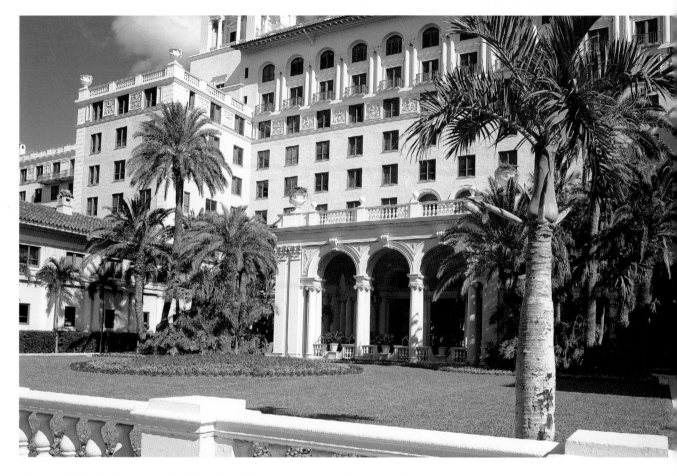

Since 1896, the Breakers in Palm Beach has been one of America's most famous hotels. The 569-room resort is built in Renaissance style and stands amid 140 oceanfront acres.

Ocean waves have carved the limestone shore into strange shapes at Blowing Rocks Preserve on Jupiter Island. During winter storms, water crashing against the rocks here sends spray up to 50 feet into the air.

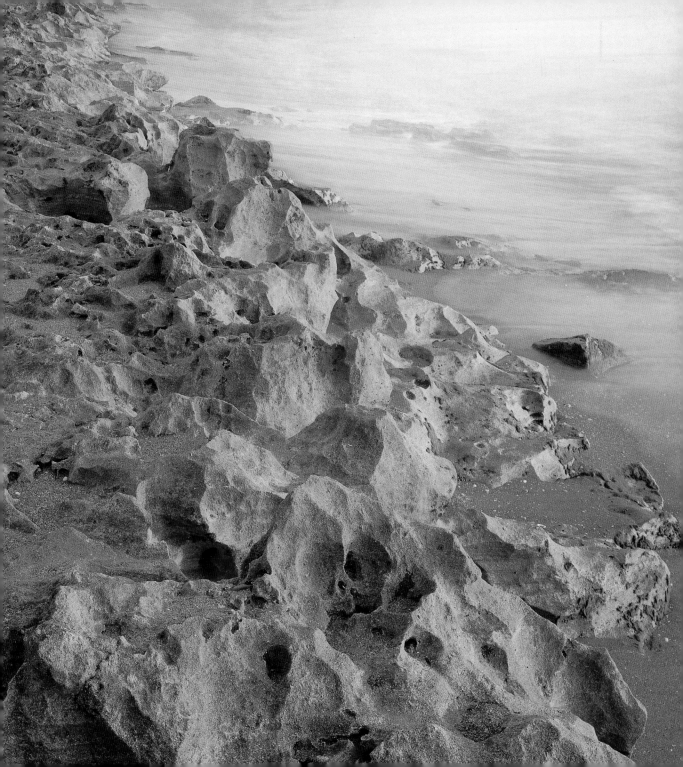

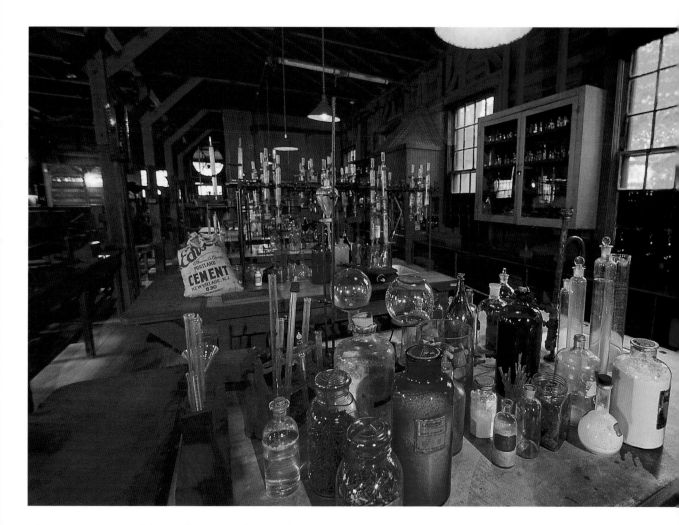

Thomas Edison and his wife, Mina, designed and built a winter
home in Fort Myers in the 1880s. By the early 1900s, the Edisons
were spending much of the season here, perfecting their home and
working in their lush garden, which has more than 300 plant varieties.

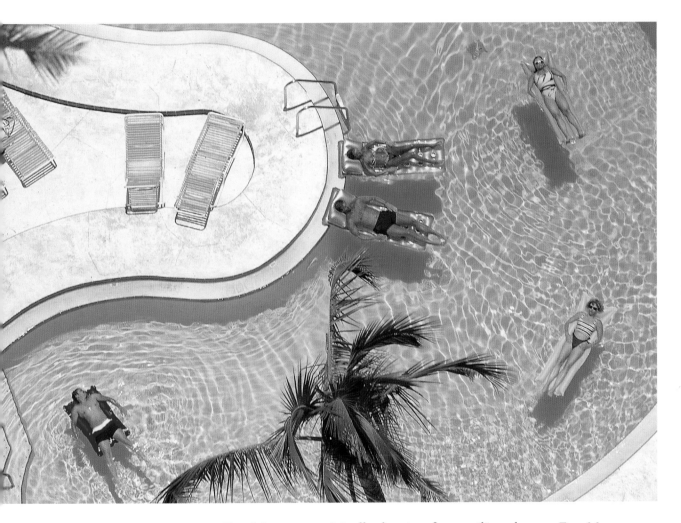

Fort Myers was originally the site of two military bases—Fort Myers, built along the Caloosahatchee River to protect settlers from the Seminoles, and Fort Harvie, built farther inland on the site of today's downtown core, away from the force of the hurricanes.

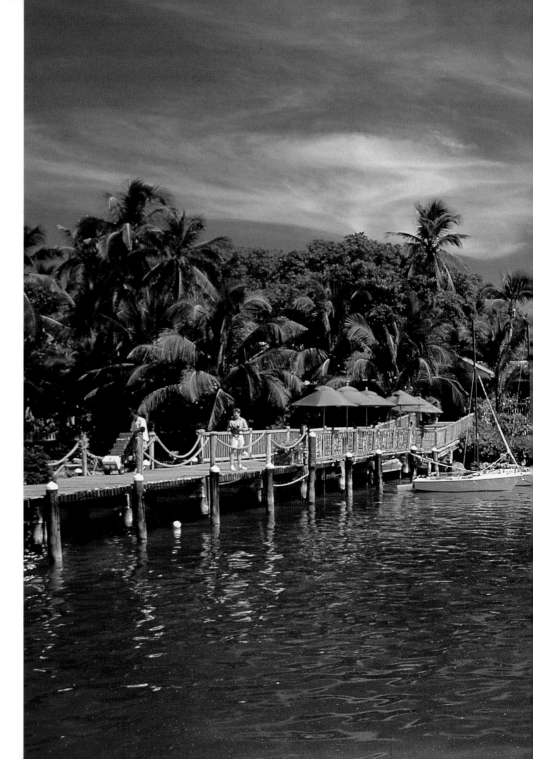

In the early 1500s, Spanish explorers became the first Europeans to travel the Florida Keys. The region remained under Spanish control until 1763, when it was traded to the British government.

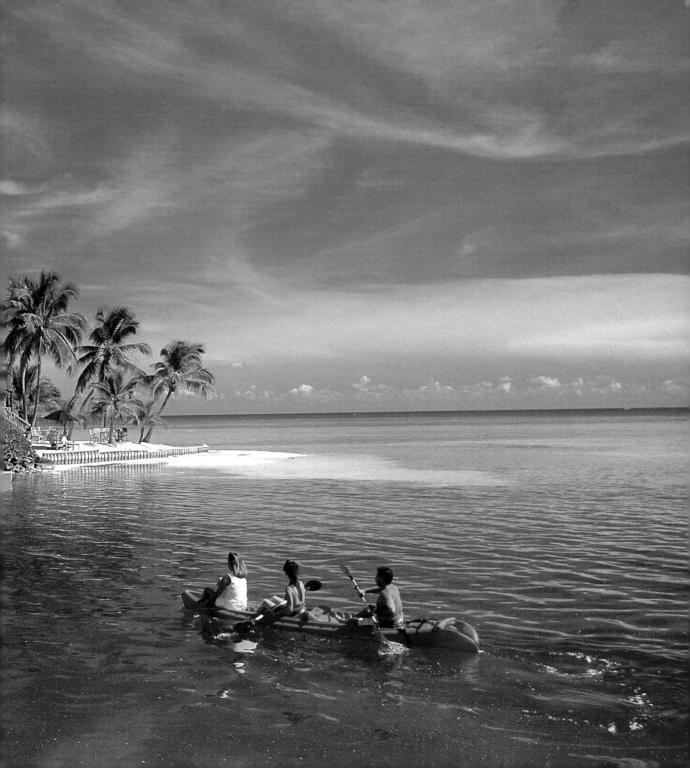

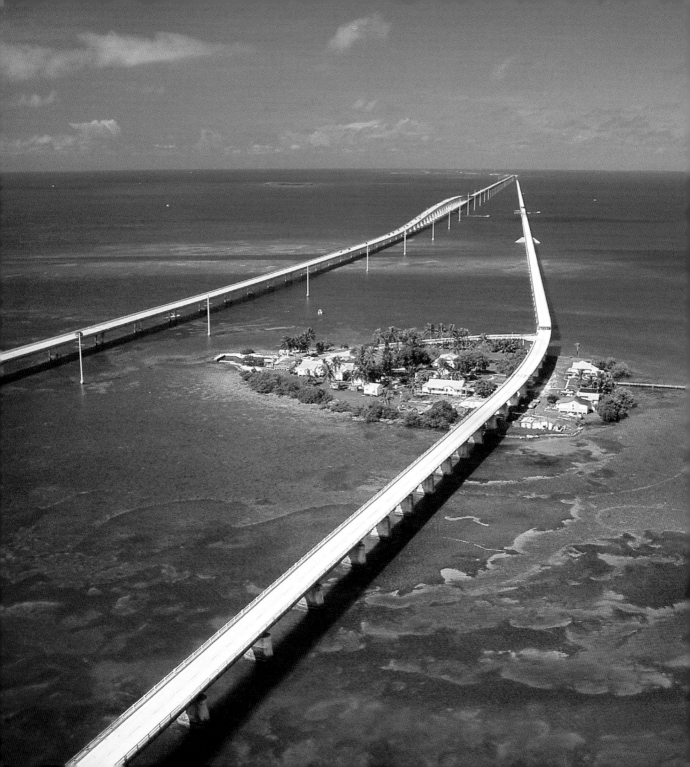

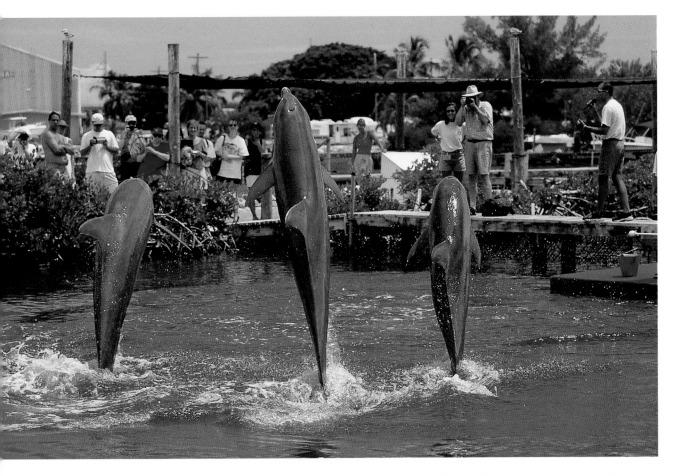

The Dolphin Research Center prides itself on rescuing stranded whales and dolphins and its success in breeding dolphins in captivity. The nonprofit center also focuses on educational programs and efforts to protect Florida's rare marine species, such as the manatee.

he Florida Keys include more than 800 islands, the highest
sing only to 18 feet above sea level. Formed by gradual sediment
eposits, the islands rose from the sea 20 to 30 million years ago.

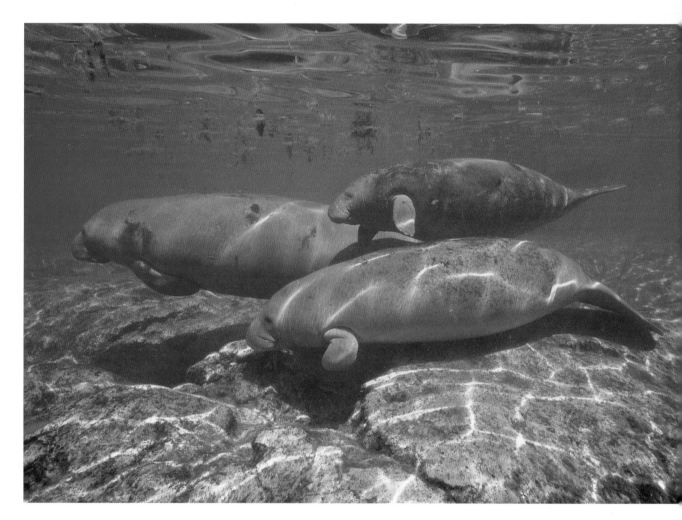

An endangered species, the West Indian manatee feeds on aquatic grasses. A 1,000-pound male can consume more than 100 pounds in a single day. The animals often swim just below the water's surface; boating accidents are a major reason their population is threatened.

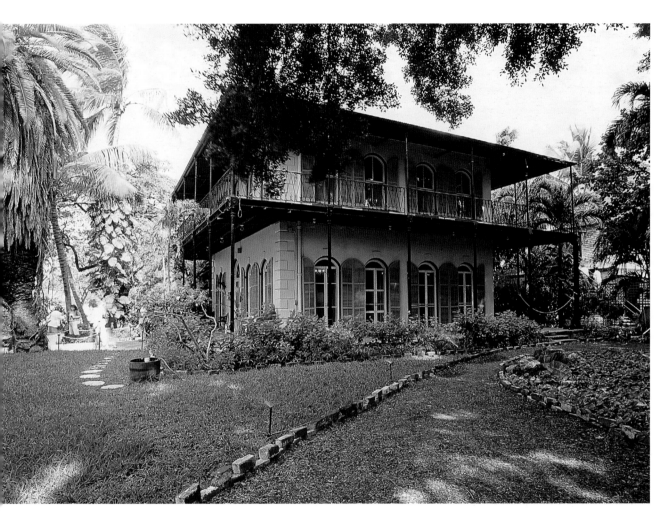

Ernest Hemingway owned this house in Key West from 1931 to 1961. Legacies of his time there remain, from the $20,000 swimming pool—the first in Key West—to the kittens that roam the grounds, descendants of the late author's 50 cats.

The arid islands of Dry Tortugas National Park are known for two things —their thriving bird and marine animal populations, and their history of pirate hideaways and buried treasure. When Spanish explorer Ponce de León sailed by in 1513, he stocked the holds of his ships with the meat of the sea turtle, or *tortuga*.

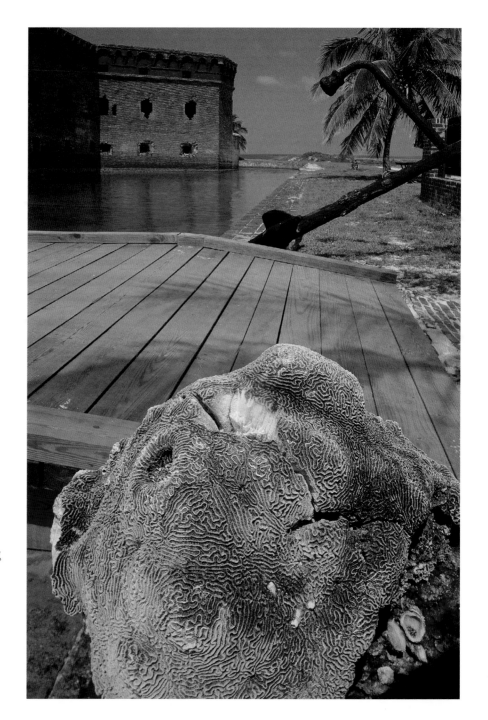

Now part of Dry Tortugas National Park, Fort Jefferson was originally a major defence post along the Atlantic coast, able to house 1,500 men. The fort was never attacked. It was declared a national monument in 1935.

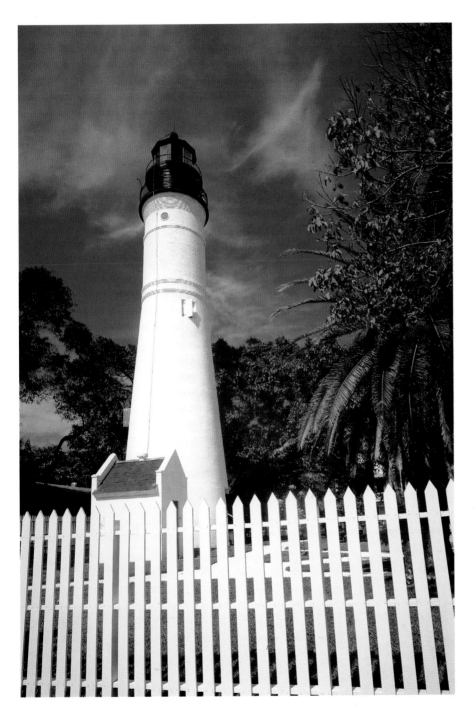

When a massive hurricane struck Key West in 1846 it obliterated all traces of the original 1825 lighthouse, leaving only a long stretch of beach in its place. A new beacon was built in 1849 and added to in 1873.

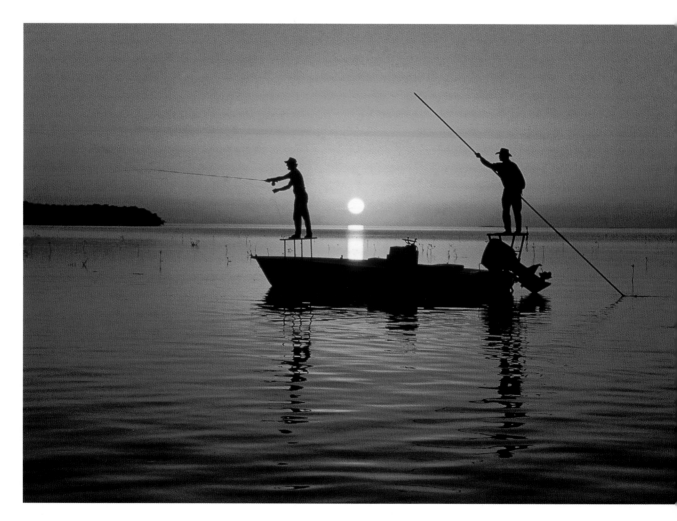

From locals casting for bonefish to enthusiasts in search of new
salt water fishing records, Key Largo is a haven for anglers. Divers
also flock to the island, exploring sunken ships, coral reefs, and an
unmatched abundance of sea life.

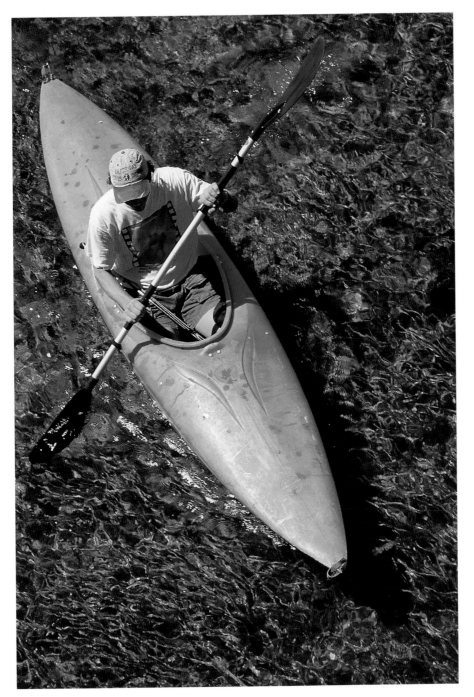

East of the Keys, kayakers and divers glimpse colorful tropical fish, denizens of the nation's only living coral reef. The third largest in the world, the reef is the result of centuries of undisturbed growth— coral grows only half an inch to 4 inches each year.

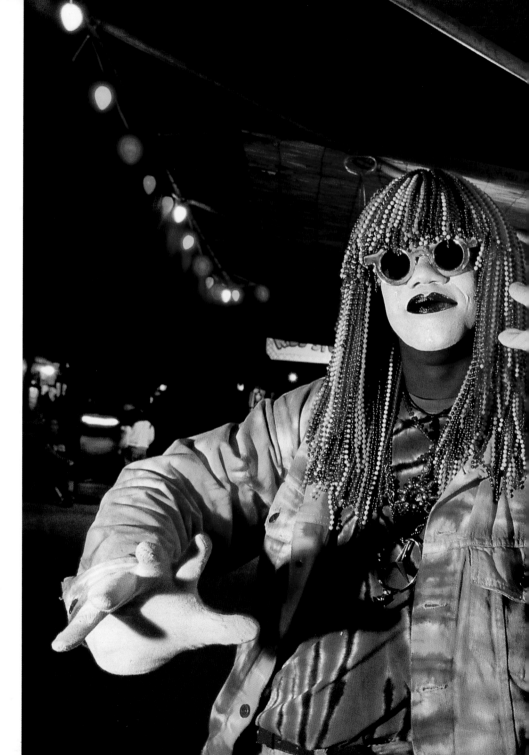

Mallory Square is a favorite with Key West visitors, in part because of the antics of various street performers here each evening. Key West is the southernmost of the islands, only 90 miles from Cuba.

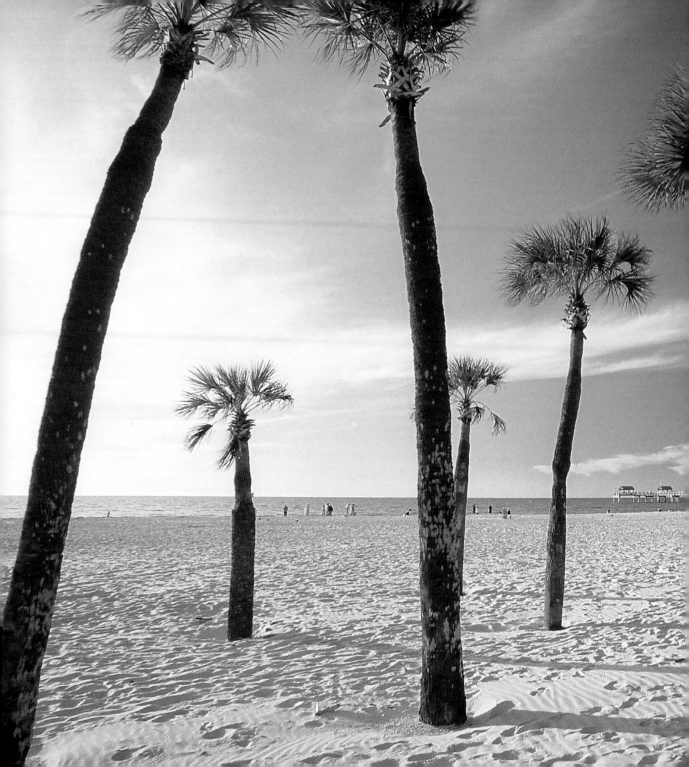

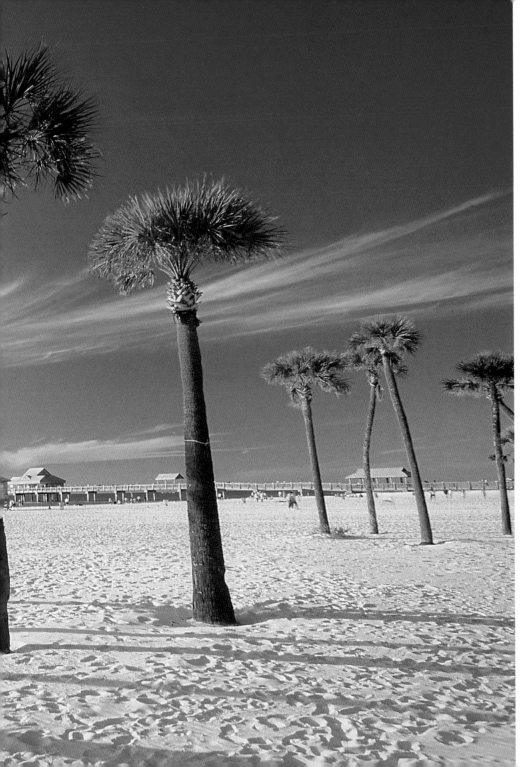

The attractions of Clearwater Beach extend from sunbathing and parasailing to fresh seafood and Greek cuisine. Nearby Pier 60 Park offers playgrounds, concessions, and entertainment.

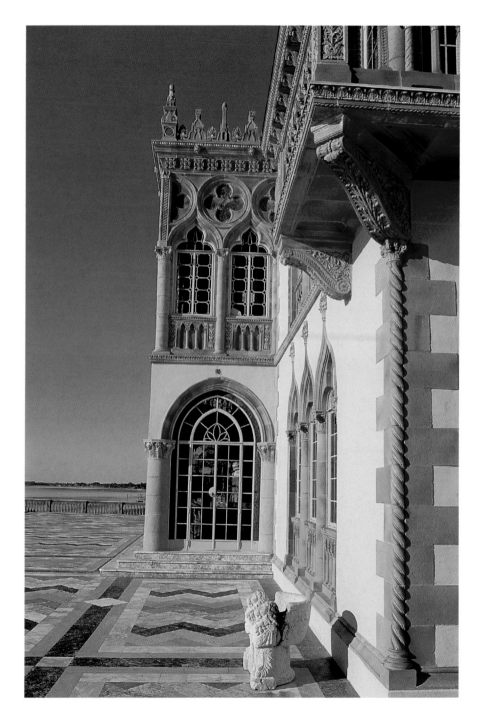

From 1927 to 1960, Sarasota was the off-season home of the Ringling Brothers and Barnum and Bailey Circus. A museum now houses artifacts, from costumes and equipment to performance posters and photos.

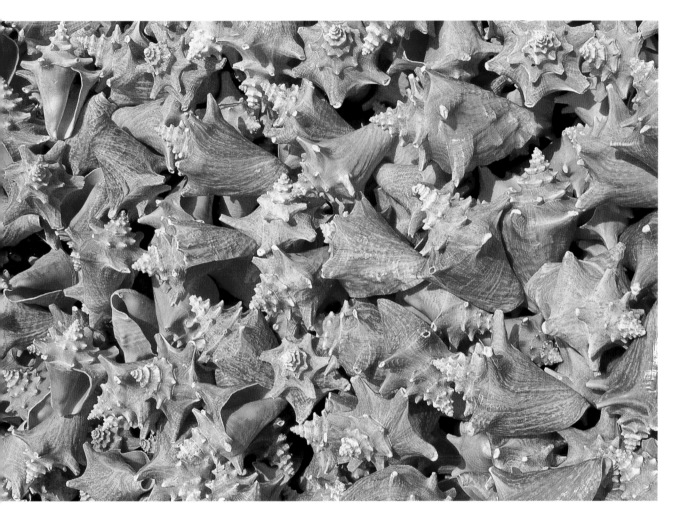

Florida's famous conchs are just a few of more than 50,000 mollusk species that populate the world's oceans. Their meat can be found in soups and stews, while their shells are popular souvenirs.

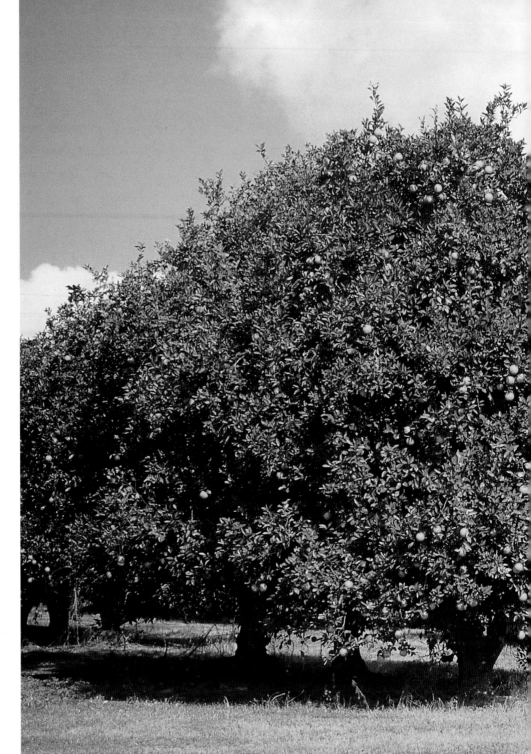

Florida orange growers practice a unique science. The oranges are allowed to ripen on the trees while growers test small samples for a mix of sugar and acid. Once the oranges achieve a perfect balance, laborers pick the fruit by hand.

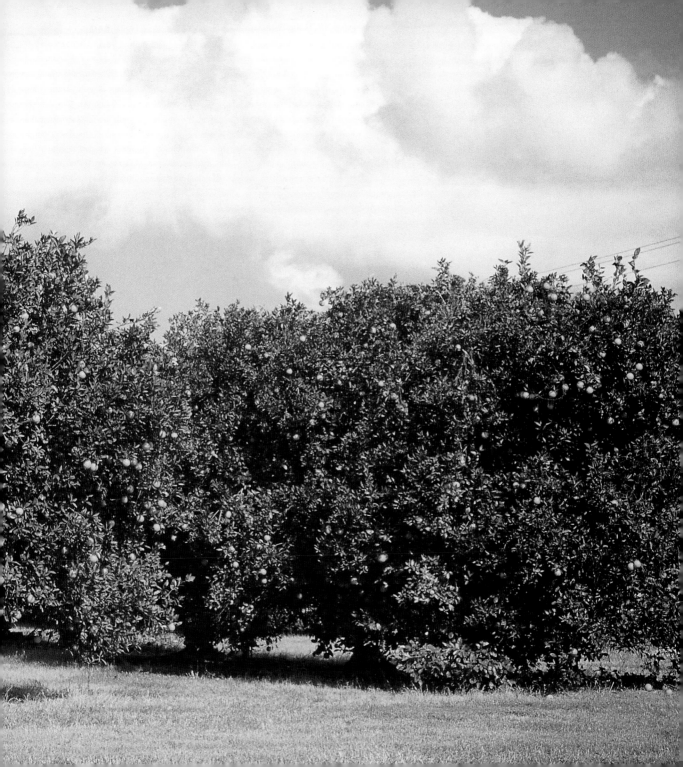

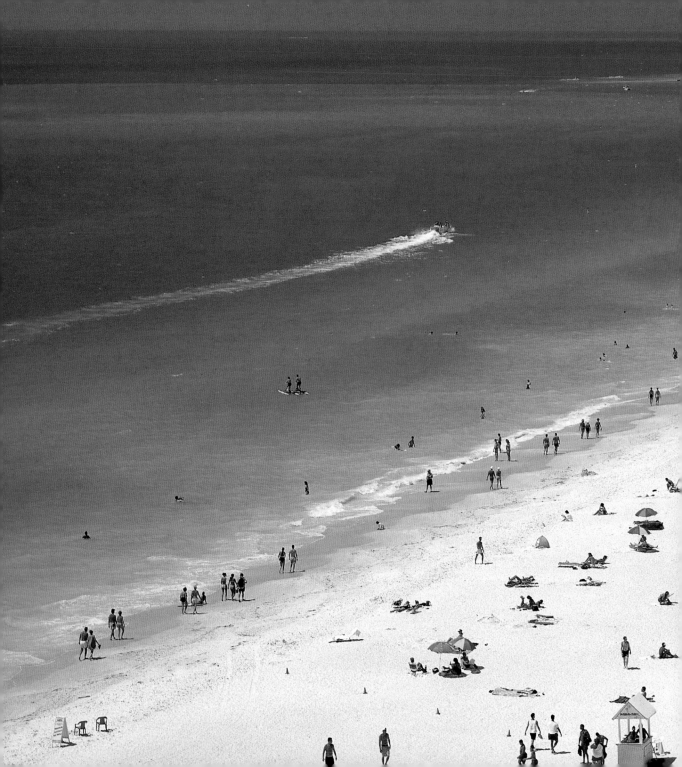

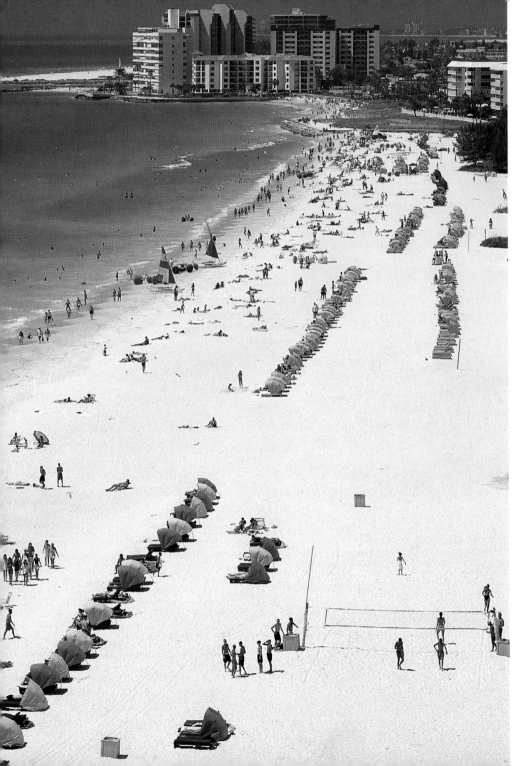

The St. Petersburg area boasts a mosaic of culture and history. The native people who first fished along these shores were joined by Spanish explorers, French plantation owners, Scottish merchants, Russian railway barons, Greek divers, and many others.

Tampa's history is connected to the mining industry, with Tampa Bay providing convenient shipping for the region's phosphates. Today, Tampa is the seventh-largest port in the United States.

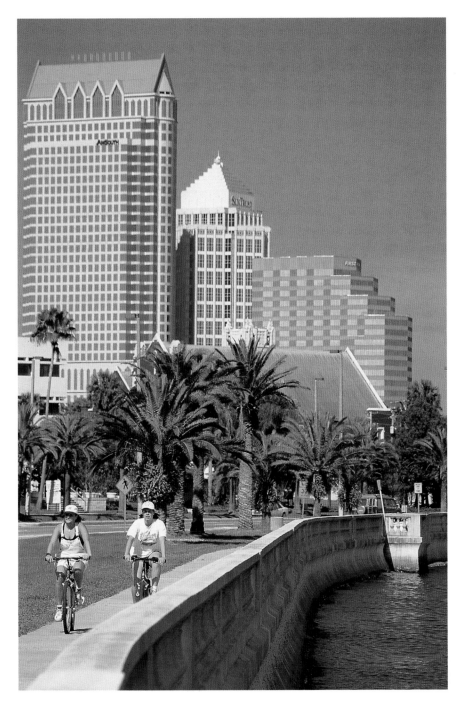

Cyclists enjoy Tampa's
Bayshore Boulevard,
often sharing the route
with in-line skaters,
joggers, and walkers.
Unbroken for more than
four miles, the boulevard
is billed as "the world's
longest sidewalk."

The 335 acres at Busch Gardens in Tampa Bay combine the wonders of a zoo with the thrills of a theme park. Passengers on the 7,000-foot track of the Gwazi roller-coaster whiz past other speeding cars just a few feet away, while visitors to the Serengeti Plain exhibit come face-to-face with giraffes, antelopes, and ostriches.

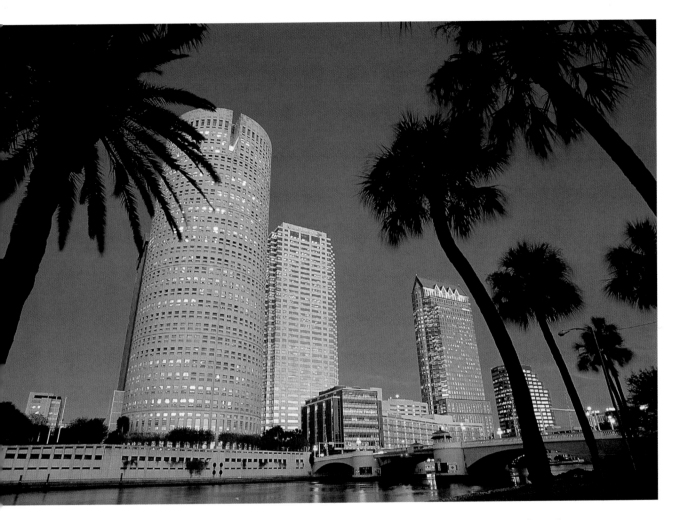

Tampa, St. Petersburg, and Clearwater are all referred to as Tampa Bay. The bay itself is a shallow estuary—the largest in the state—covering almost 400 square miles.

Extending four miles across Tampa Bay, the Sunshine Skyway Bridge was built in 1982. The previous span was destroyed in 1980, when a freighter collided with the bridge during a storm, damaging a 1,200-foot portion.

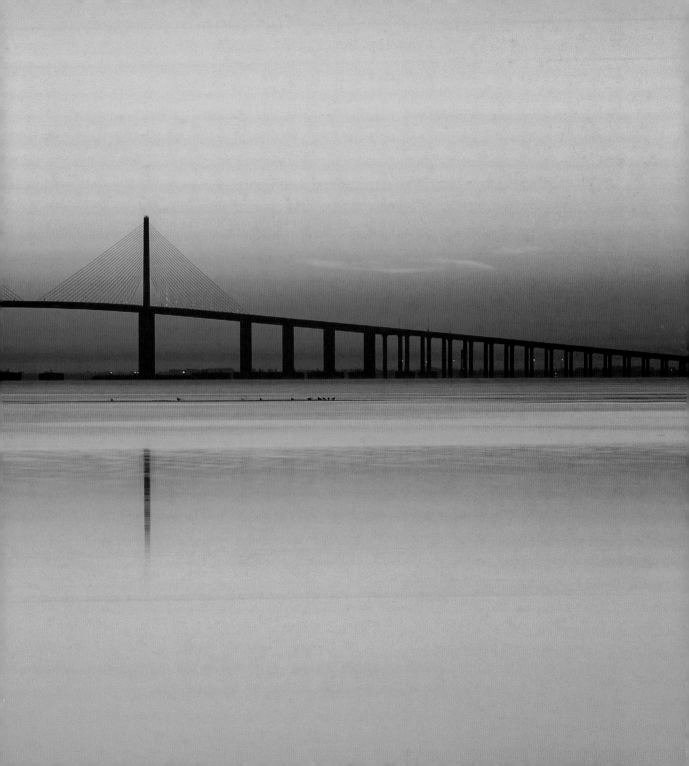

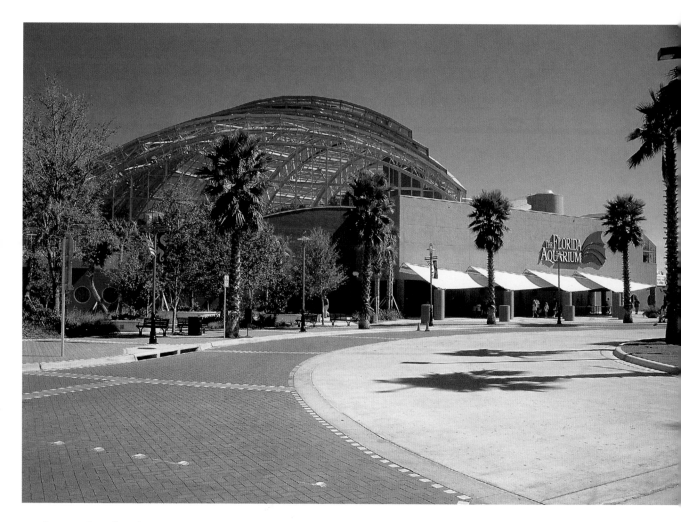

Exploring the Florida Aquarium in Tampa, sightseers follow a drop of water from an underground spring to the Atlantic. Along the way, more than 10,000 plants and animals await.

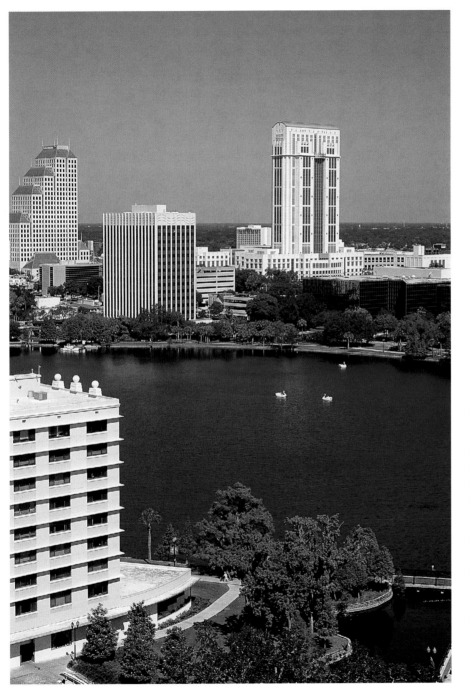

Festivals and events keep downtown Orlando in a constant state of celebration. The Orlando International Fringe Festival, the Street Painting Festival, Shakespeare performances, parades, and Fourth of July events keep residents busy all year long.

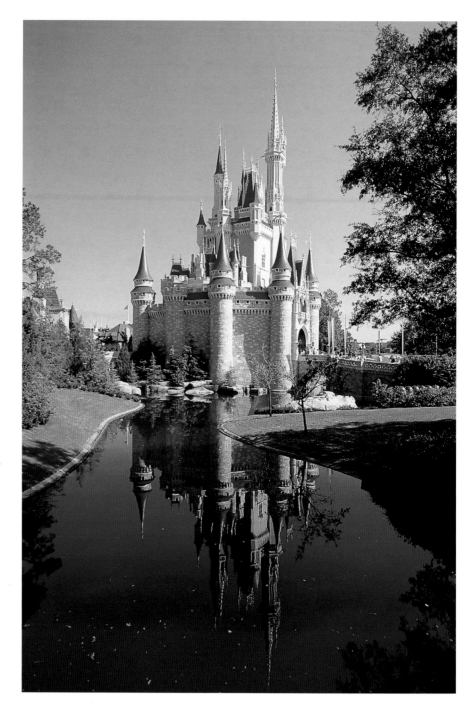

In Main Street USA, part of Disney's Magic Kingdom, bands play in the town square, magical characters inhabit a charming nineteenth-century town, and steam whistles announce the arrival of the latest trains. Overlooking the activity is Disney's trademark majestic fairytale castle.

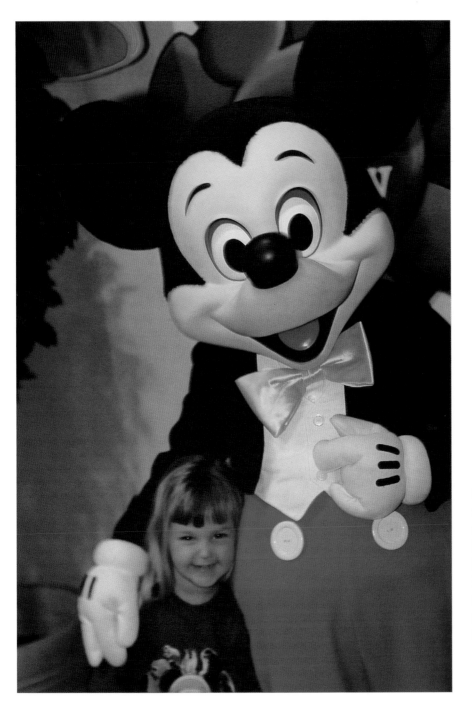

In Fantasyland, visitors meet Disney's most famous characters, from Mickey Mouse and Peter Pan to Simba the Lion King and Dumbo. Popular rides, such as the Mad Tea Party and It's a Small World, add to the excitement.

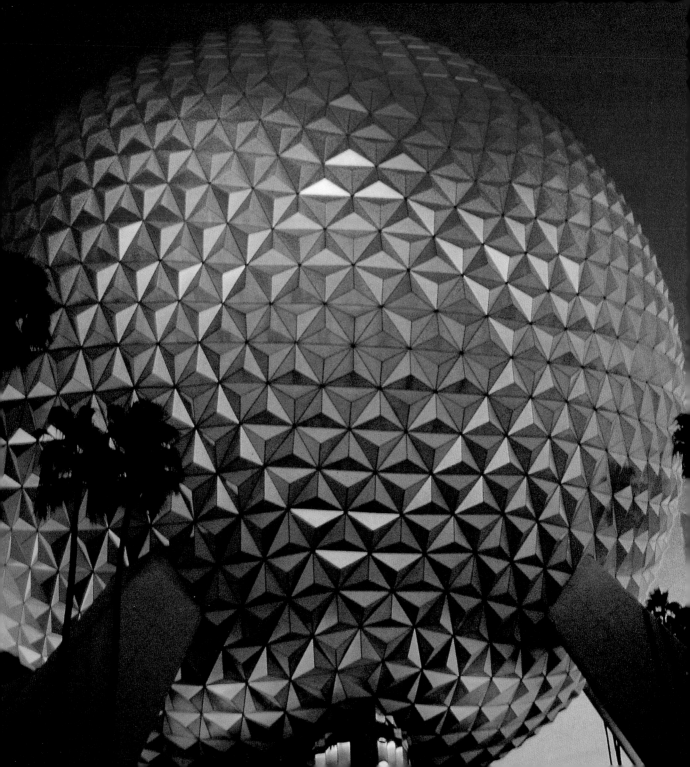

Combining Future
World, an educational
look at science and
new technologies,
and World Showcase,
with pavilions that
represent nations
from Mexico to
Morocco, Disney's
Epcot Center is one
of Orlando's most
popular attractions.

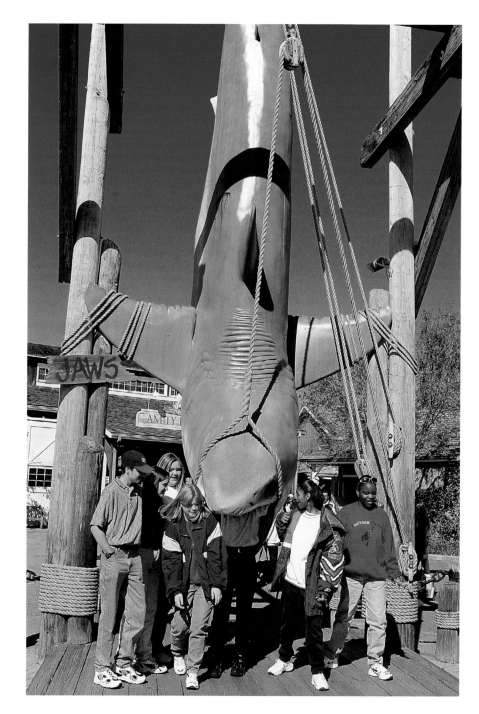

At Universal Orlando, movie buffs can go behind the scenes at Production Central to discover how movies and cartoons are made. The nearby Islands of Adventure exhibits offer a tour of Jurassic Park, a trip through Toon Lagoon, and much more.

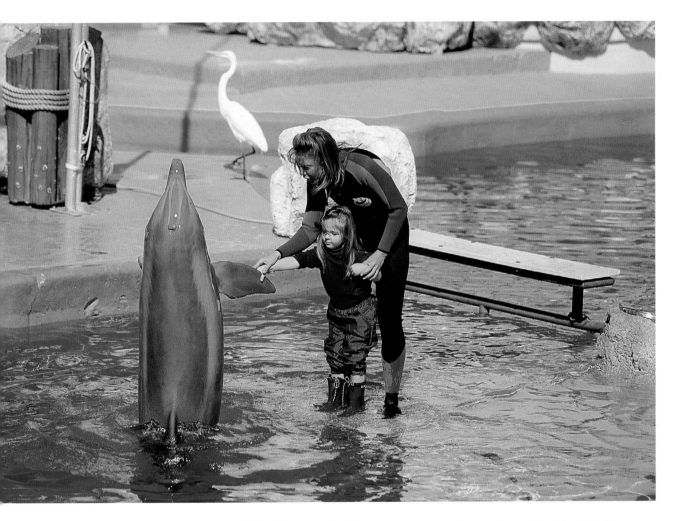

Polar bears, dolphins, manatees, and penguins—SeaWorld Adventure Park is home to creatures from around the world. Visitors can dip their hands into a Caribbean tide pool or wander through the 30-foot-tall bamboo of a tropical rainforest.

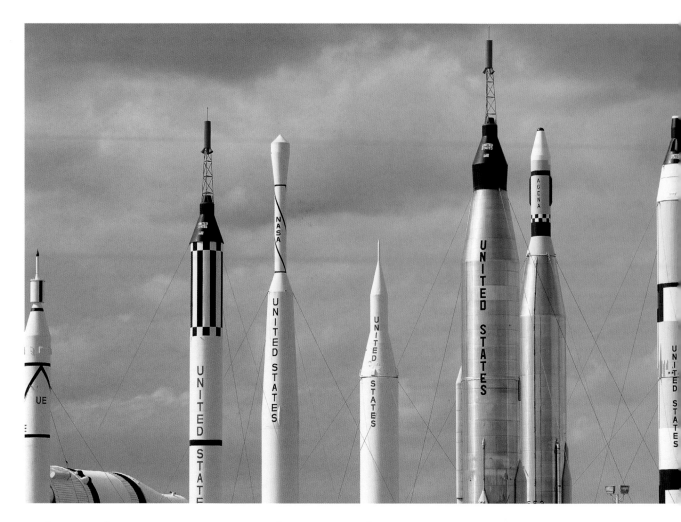

At the Kennedy Space Center, scientists and engineers work to launch unmanned rockets and manned space shuttles, most from the Cape Canaveral Air Station. At take-off, a 220,000-pound rocket reaches 10 times the speed of a bullet in less than nine minutes.

Surfers challenge the swells, families picnic in the beachside parks, volleyball players churn up the sand—Cocoa Beach encompasses everything a sunseeker could wish for.

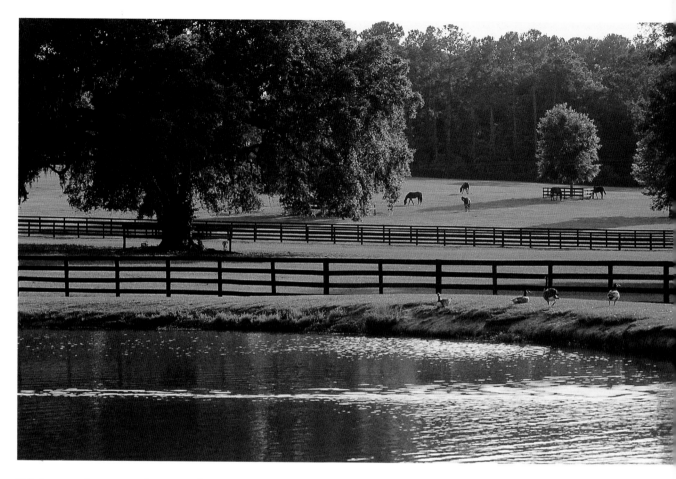

With more horses and ponies than anywhere else in America, Ocala's horse farms are big business. Over three-quarters of Florida's racing thoroughbreds are trained here.

Low tide reveals a 500-foot-wide strip of glistening white sand at Daytona Beach. These shores are the focal point for Daytona Beach recreation, including jogging, beach volleyball, picnicking, fishing, birdwatching, building sand castles, and riding dune buggies.

At Klassix Auto Museum in Daytona, exhibits glorify the history of Daytona International Speedway. The museum also includes classic car, motorcycle, and Corvette displays.

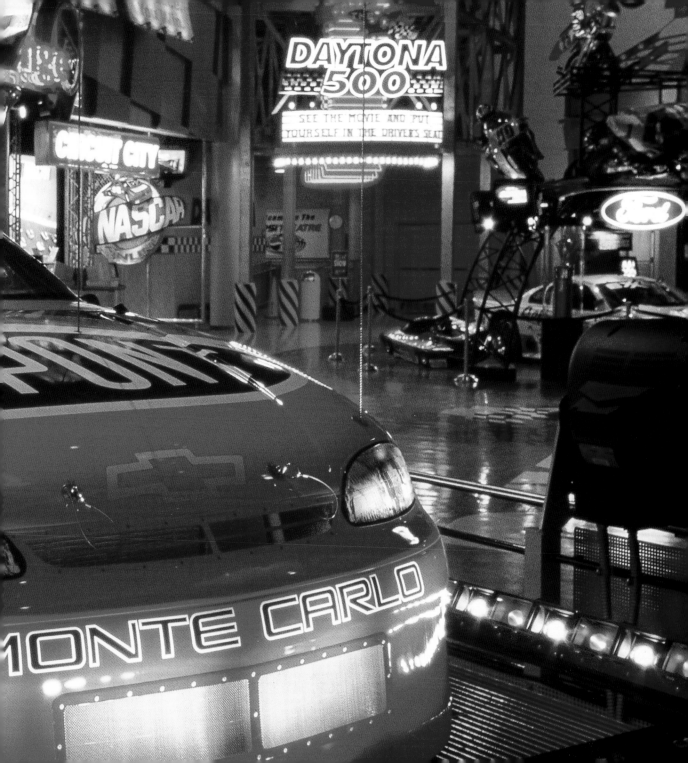

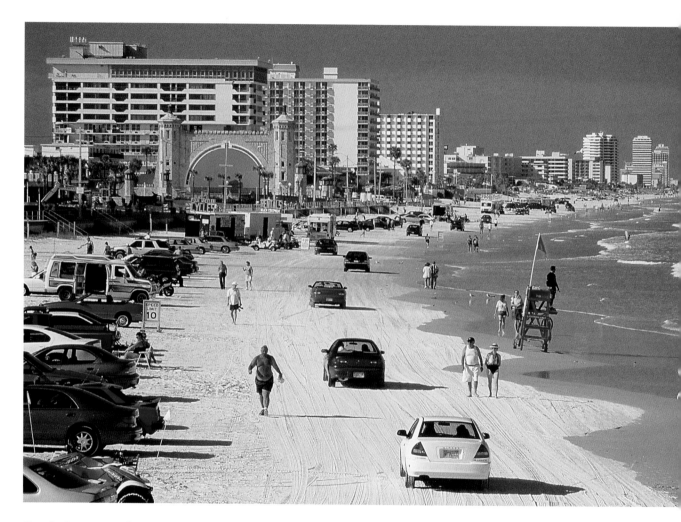

Beach driving is almost a sport on 16 miles of the city's coastline. For those looking for a more quiet escape, a one-mile stretch of sand is off-limits to vehicles and open to sunbathers.

Built in 1912, the Casements in Ormond Beach was the winter home of John D. Rockefeller. Now a cultural center and museum, the mansion is listed on the National Register of Historic Places.

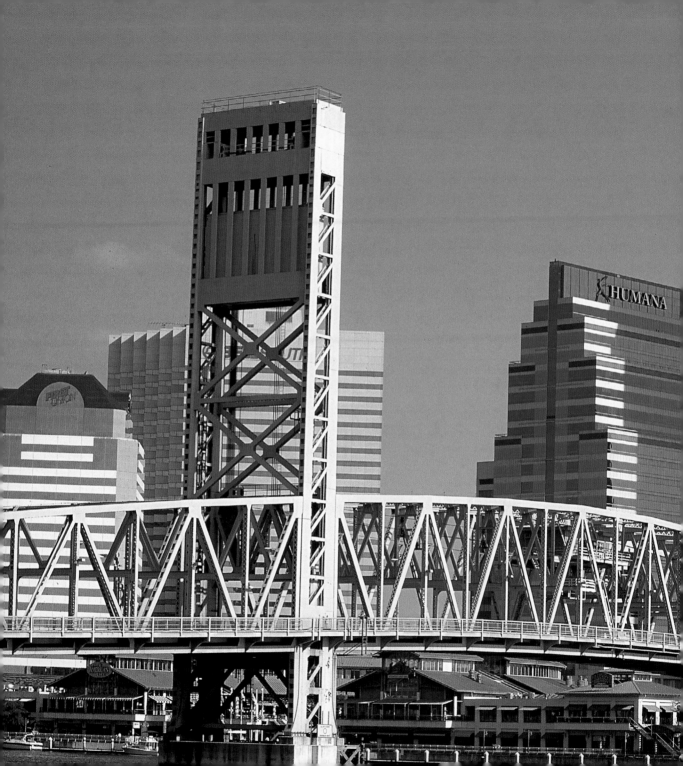

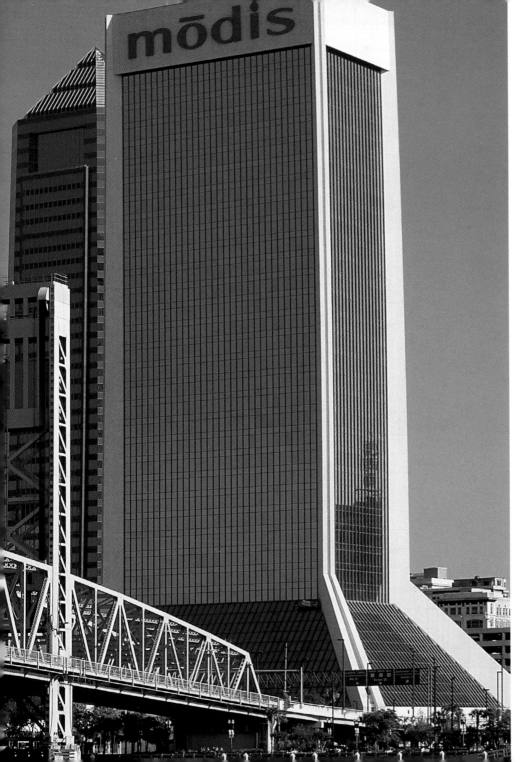

As a golfing mecca, an adventure tourism center, and a gateway to many of the region's historic sites, Jacksonville is a favorite with Florida visitors. A lively entertainment scene, shopping, and festivals add to its vibrancy.

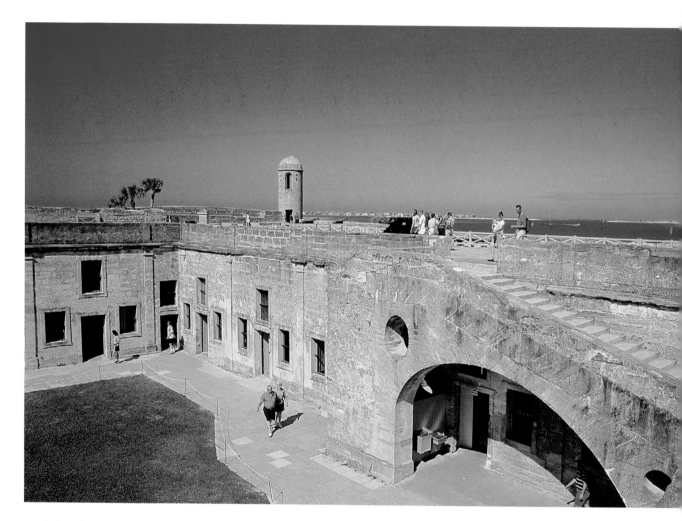

Built by the Spanish between 1672 and 1695, the Castillo de San Marcos protected the first European settlement in the continental U.S., at St. Augustine. It remains the oldest European outpost in the nation.

The expansive grounds of Amelia Island Plantation are perfect for birdwatching. The luxury resort also boasts three 18-hole golf courses, 23 clay tennis courts, and over 3 miles of beaches.

A shrimp boat
weathering a storm
in Fernandina
Beach's snug harbor
serves as a reminder
of a time when the
town was a bustling
seaport. Today,
Fernandina Beach
is still known for its
annual 2-million
pound shrimp catch
and a shrimp festival
held each May.